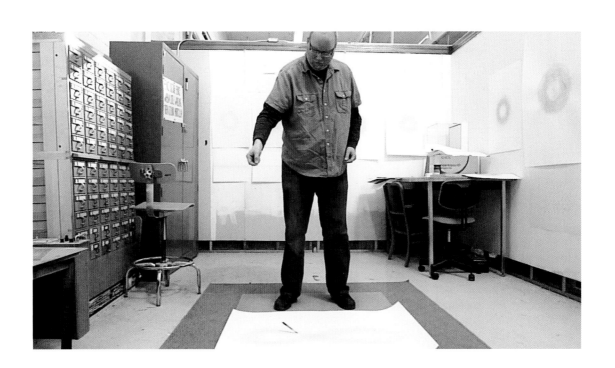

HOURS OF INFINITY
RECORDING THE IMPERFECT ETERNAL

JOHN KANNENBERG

foreword by MARC WEIDENBAUM

introduction by T. G. WILFONG

KELSEY MUSEUM PUBLICATION 8
Ann Arbor, Michigan 2012

Published by:
Kelsey Museum of Archaeology
434 South State Street
Ann Arbor, Michigan 48109-1390, USA

ISBN 978-0-9741873-6-5

Designed, photographed, & written by John Kannenberg unless otherwise noted
Typeset in News Gothic BT
Limited edition of 300 copies

Edited by Dr. Gene Kannenberg, Jr. and Dr. Lindsay Ambridge

Front cover: "One Hour of Infinity: Circle"
Back cover: One snapshot per hour while making "Thirty-Four Hours of Infinity: Lemniscate"
Frontispiece: Self-portrait while drawing "Five Hours of Infinity: Lemniscate"

For Mom and Dad, my own prime movers

This book is available directly from:
The David Brown Book Company
PO Box 511, Oakville, CT 06779, USA
Phone: 860-945-9329; Fax: 860-945-9468

and

Oxbow Books
Park End Place, Oxford OX1 1HN, United Kingdom
Phone: 01865-241249; Fax 01865-794449)
www.oxbowbooks.com

CONTENTS

INHERENT
WITHIN
THE
HUMAN
EXPERIENCE
OF
THE INFINITE
IS A
TIMELESSLY
BEAUTIFUL
IMPERFECTION.

TO FULLY
COMPREHEND
THE INFINITE
IS A
HUMAN
IMPOSSIBILITY;
TO
ATTEMPT IT
IS
TO EMBRACE
THE ABSURD.

CANTOR
& GÖDEL
GOT TOO
CLOSE.

IT DROVE
THEM
MAD.

FOREWORD by Marc Weidenbaum

Consider the word "phonography." Note for a moment that there is an "n" where normally one would expect to find a "t" residing. The term is employed with increasing frequency to describe the act of recording environmental sound, the sound around us. The term's close alignment with "photography" is helpful when orienting newcomers to field recordings. A phonographer, like a photographer, captures a document of the real world and then proceeds to frame it, transforming it from documentation into art. Photographers are taught to "frame with the lens," but of course they employ all manner of tools after shooting an image to nudge it toward what they saw with their mind's eye. Likewise, contemporary music composers frequently take field recordings and from them produce original works, in which the recordings are manipulated into something situated ambiguously between ambient sound and ambient music: what they heard with their mind's ear.

As a descriptive term, "phonography" has utility, but associations with photography are not optimal. Sound occurs over time. For that reason, field recordings have more in common with film and video than with photography. One can stare at a photograph, step away, return to it. But a recording of sound or visuals, or both, plays back at its own pace; the audience can only appreciate it as it speeds past them, much like the tireless motion of history.

History can itself serve as a frame. In 2010, the artist John Kannenberg took a trip to Egypt, where he made detailed audio recordings in and around local museums. The Western imagination associates Egyptian antiquity with the deepest recesses of human history, a moment akin to dawn along the infinite developmental timeline of intellectual consciousness; the setting lent his work spiritual as well as archaeological timbres. By documenting the sound of museums, he turned the concept of "sound art" inside out: listening for sound inherent in institutions that house art.

Little did he know that in less than a year, one of those museums would become a battlefield in the Egyptian Spring, a political uprising that in its first few days took the life of a promising Egyptian artist named Ahmed Basiony. In short order, sounds Kannenberg recorded in the spirit of John Cage's *4'33"*—to acknowledge the transient beauty in everyday sound—became a retroactive, somber memorial; a document of observational neutrality took on political force. Kannenberg had done nothing to alter the sounds he recorded, imposed no filters, added no instrumentation. History had done the work. The sounds of museum-goers' footsteps became those of ghosts.

There are various sorts of history. Among them is the linear course of an individual artist's career. Kannenberg's has taken many shapes: musician, performer, recording artist, proprietor of the Stasisfield record label, curator, sound artist, visual artist, art student. Each new work of his joins the continuity of what preceded it; each new work alters our understanding of what occurred earlier. The Red and Black Land drawings become extensions of visuals he oversaw on Stasisfield productions. The sound installations expand on his early recorded material. And by actively occupying a museum for his latest work, he can be heard, himself, wrestling with its ghosts.

THE AC·TIVE SOUNDS OF HIS·TO·RY

[ðə ǽktɪv sáwndz əv hístəri]

descriptive epithet.

Sonic events produced by the intermingling of contemporary museum

visitors and the historical objects contained therein (e.g. the reverberations

of sculptures and the muffled thuds of paintings colliding with the sounds

of mobile phones, squeaky floors, coughing, elevator bells, crying babies,

HVAC systems, camera shutters, docent tours, audio installations, toilet

flushes, film projectors, water fountains, gift shop cash registers, dangling

jewelry, athletic shoes on newly waxed floors, synthetic fabrics rustling

against skin, raised voices of patrons using an audio tour, etc.).

(Derivation: Early 21st century Artspeak)

INTRODUCTION by T. G. Wilfong

The ancient Egyptians understood two types of time, encapsulated in their two words for "eternity": *djet* and *neheh*. Djet-time is discrete, separate points of time at a standstill, an infinity of individual moments with no real implication of a progression of events. Neheh-time, on the other hand, is cyclical, endless cycles of repetition. These two understandings of time affected how the Egyptians experienced the world. Days, months, years, king's reigns, life-times: all were endlessly repeating cycles against which individual moments were plotted. The cycles in which time passed mirrored each other: the daily cycle of the rising and setting sun could be the image of annual agricultural cycle of inundation, growth, and harvest, or the accession, rule, and death of a king, or the cycle of birth, life, and regeneration in the after-life. John Kannenberg's drawings encapsulate both types of eternity in ancient Egypt: neheh-time in the repeated circlings of the pencil over paper and djet-time in the visible marks of the points of the pencil as it hits the paper: points of djet-time in an endless cycle of neheh.

John's work connects to many of the ancient Egyptian objects in the Kelsey Museum, both on display and in storage. The mummy case of Djehutymose, a priest who lived over 2,500 years ago, is encircled by a snake swallowing its own tail, another illustration of cyclical eternity and encircling. The hieroglyphs in John's Kelsey Museum drawings are seen in many of the Egyptian inscriptions and texts in the Kelsey; indeed these hieroglyphs convey many of the basic Egyptian understandings of time and the world, and they appear in nearly any text in the ancient Egyptian language. In storage, two fragmentary manuscripts of the Egyptian *Book of Amduat*, "What is in the Netherworld," feature texts written in black and red ink, with drawings that show the Egyptians' vision of the sun's nighttime journey through the Netherworld. The use of red and black reflects Egyptian textual practice: in religious and literary texts, black was used for main text and red for headings, instructions, and exegesis.

John Kannenberg's site-specific installation and performance, *An Hour of Infinity,* will bring together his artistic practice and the different galleries of the permanent installation of the Kelsey Museum of Archaeology, a reflection of the interconnections among the different cultures of the ancient Mediterranean world. As visitors tour through the galleries on the evening of the piece, John and his performers will bring together a complex interaction of drawing, video, and sound to carry museum visitors through encounters with ancient Egypt, Mesopotamia, Greece, and Rome.

Hours of Infinity is the second in what we hope will be a regular series of exhibitions at the Kelsey Museum of Archaeology in which University of Michigan Art and Design faculty and MFA students engage with the Kelsey and its collections. The first such exhibition, *Personae*, the MFA thesis exhibition of Reem Gibriel, featured a complex installation inspired in part by the forms of ancient amphorae—two-handled wine jars common throughout the ancient Mediterranean world. John Kannenberg's *Hours of Infinity* now brings artistic performance into the Kelsey, further underlining the dynamic nature of artists' experience of the museum and its collections.

\<begin\>

IF

{
A RECORDING = THE PRESERVATION OF LISTENING

A LINE = A RECORD OF ACTION

A DRAWING = A RECORDING OF ACTIONS OVER TIME
}

THEN

{
DRAWING = LISTENING
}

\</withoutEnd\>

RULES FOR LISTENING TO TIME ARTIST'S STATEMENT

The solitary acts of drawing and listening are inextricably linked; they both observe and record each other.

The three projects comprising *Hours of Infinity* are based upon an imprecise drawing method that causes mistakes to be embedded within the work by separating the creator from the physical act of drawing, all the while maintaining focused attention on the sonic aspects of the experience—the sound of the pencil against the paper and its merging with other sounds within the surrounding space. The visual symbols I have chosen to depict with this process have represented infinity within various cultures over long spans of time; thus there is a calculated contradiction inherent within the small size and impermanent materials of these drawings, between their own ephemerality and the eternity they represent. Incorporating in their construction elements of classical Egyptian and Greek philosophies, mindful meditation, and proofs from mathematical theory, these works investigate the timelessly beautiful imperfection inherent within the human experience of the Infinite. The drawings themselves are weightless objects, etched documents, their grooves and lines indicative of the sounds of specific durations of time: imperfect, absurd, fragile symbols for something believed to be symmetrical, profound, and everlasting.

My favorite aphorism within Brian Eno and Peter Schmidt's *Oblique Strategies* instructional cards for artists is "Honor thy error as a hidden intention." I've often found the easiest way to produce desirable artistic errors is through collaboration; in the combination of two or more sensibilities it can be easier to explore the unknown, the uncomfortable, the avoided. By accepting these collisions of fate as decisions rather than barriers, I open myself up to new ways of seeing, or doing, or listening. In the work I make as a solitary artist, I create situations that provoke similarly acceptable "errors." So now, I draw with fishing line.

Opposites attract me. I experience wonder in the foregrounding of background; I find beauty in listening to the unheard. When an action becomes expected, I often feel compelled to pursue its opposite. I see power in the negation of a positive: light versus dark, loud versus quiet. In focusing on contradiction as a creative strategy, I embrace the existential notion of the absurd. Albert Camus uses the absence of sound as an example of the absurd in *The Myth of Sisyphus*: "A man is talking on the telephone behind a glass partition: you cannot hear him, but you see his incomprehensible dumb show: you wonder why he is alive." Vision without sound is one aspect of the absurdity of existence. If I want to explore the absurd, why not create an artwork of contradiction? Why not attempt to collect sound by drawing time?

Bearing witness to the power of time can inspire awe: touching an ancient object, witnessing an eclipse, listening to a sound recording made before you were born. Time itself cannot be controlled, but the perception of its passing may be altered. Truly attentive listening requires suspending one's perception of time—or at least the ability to disregard how long it takes.

It's tempting to think of the experience of time as linear. Time only seems to move in one direction: forward. Yet we all spend much of that linear time dwelling on events of the past

or anticipating events of the future. This merging of past, present, and future is much the same as my experience of time and history while visiting a museum.

My sense of history in a museum is seldom linear. Even if the exhibition designers have organized the collections chronologically, visitors rarely follow that intended path. Museum visitors follow paths that often, if not entirely, involve a great number of chance operations in tandem with a curatorial guide who, unavoidably, is only partially in control of the situation. When I walk through a museum, I travel through non-linear time. And often, I record the sounds I hear in museums as a method of *collecting* time. Museums as sonic environments contain a record of the present day mingled with the past. Every echo, every footstep, every floor creak that I record while visiting a museum captures information about my time in that place—but it also captures information about how contemporary sounds are affected by historical objects. Paintings absorb sounds, sculptures reflect them—these are *the active sounds of history*. Can objects retain a record of these sonic collisions? Do objects remember us through sound, and us them?

Museums collect, preserve, and present histories. Those histories are told to us through the objects these institutions have acquired over time: temporal ephemera, mute vessels. It's through the display of these objects in deliberate proximities to each other that they begin to resonate, are imbued with meaning, as the museum theorists Spenser Crew and James Sims have stated. I follow this approach in my own artwork: by combining different, seemingly meaningless, sounds and processes, I allow their juxtaposition to create meaning in tandem with their audience. Like a museum, I present what I collect: the sounds that I record.

A recording of a sound is never the same thing as the sound itself; similarly, a drawing is not the same as the physical act it took to make it. In exploring new drawing methods I have found myself creating situations in which I am unable to actually complete the task I set out for myself. In repeating non-successful actions for long durations of time, I seek a positive by working through a negative. It's a constant act of *trying* to do something rather than *accomplishing* it. What is left is something profoundly human: all that I can do. It's the result of listening to my surroundings, and to myself; a record of an attempt, a series of imperfect, ephemeral objects.

The more I have actively listened to my surroundings and made recordings based on careful observation, the more I've become interested in translating this activity to the act of drawing, something that used to be my primary discipline as an artist. Add to this my interests in non-linear time and the sonic experience of museums, and *An Hour of Infinity*—a performance at the Kelsey Museum consisting of drawing, recorded museum sound, and visually composed music—becomes one logical outgrowth of this continuing body of work.

Through this act of *drawing the act of listening* while in an archaeology museum—this absurd, contradictory, *visual* method of recording and collecting *sound*—I feel I've taken another step closer toward achieving an ultimately unreachable goal: listening to time itself.

ONE HUNDRED HOURS OF INFINITY

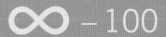 – 100

ABOUT *ONE HUNDRED HOURS OF INFINITY*

This collection of meditative drawings accompanied by a sound and video installation is the first set of work in a series that explores the timelessly beautiful imperfection inherent within the human experience of the Infinite.

In the early months of 2011, I began experimenting with new ways to connect my long-standing practice of field recording/attentive listening with drawing, an activity that once consumed my life but one that I had abandoned about a decade ago. I began a series of time-based drawings of circles made by dangling a charcoal pencil attached to fishing line over a piece of paper placed on the floor. Experiments with other shapes led me to attempt drawing the **lemniscate**, the sideways "figure eight" that symbolizes infinity. I wrote titles on these drawings, more like instructions—statements like *Trying to draw a circle for 30 minutes straight with a piece of charcoal attached to fishing line*—but after drawing the lemniscate, I instinctively wrote *One Hour of Infinity* on the drawing instead. The spontaneous poetry of this statement struck me, and I began researching the Infinite. Eventually, the title *One Hundred Hours of Infinity* came to me, and the pieces of the process that led to the creation of this exhibition began locking into place.

The Fibonacci Sequence felt like a natural set of numbers upon which to base the durations of the drawings in the show. This numerical sequence consists of a set of numbers whose values always equal the sum of the previous two numbers (0, 1, 1, 2, 3, 5, 8, 13, etc. *ad infinitum*). Its connections to the Golden Rectangle of proportions have made it a tool used by artists for centuries. However, there was no easy way to make the numbers in the Fibonacci Sequence add up evenly to one hundred, so I finessed the numbers and came up with a three-part combination of hours and minutes that did.

The **Prelude** would include a ten-hour drawing of the oldest symbol representing the concept of infinity I found in my research: the ancient Egyptian hieroglyph *shen*, which, when stretched vertically, also formed the cartouches that surround the names of pharaohs in ancient texts, offering the names of royalty eternal protection.

The **Sequence** would contain the first ten numbers in the Fibonacci Sequence, from zero to thirty-four. Alternating lemniscates and circles would allow me to add a rhythmic visual element to the set of drawings by switching between vertical and horizontal compositions.

As the final "movement," the **Coda** would act as a visual "fade off," returning the viewer to their own realm of existence after experiencing the previous segments of timelessness. These six drawings would repeat the first six numbers of the Fibonacci Sequence in reverse, each number multiplied by ten and counted in minutes, not hours.

Realizing that there would need to be two instances of "zero hours" in the show (since the first number of the Fibonacci Sequence is zero), I hung two blank sheets of paper on my

SET: ONE HUNDRED HOURS OF INFINITY

SUBSET 1: PRELUDE - The Four Shens

10 hours

SUBSET 2: THE SEQUENCE - Apeiron (α), Lemniscates and Circles

| 0 hours | 1 hour | 1 hour | 2 hours | 3 hours | 5 hours | 8 hours | 13 hours | 21 hours | 34 hours |

SET 3: CODA - Circles, a Lemniscate and Apeiron (Ω)

| 50 minutes | 30 minutes | 20 minutes | 10 minutes | 10 minutes | 0 minutes |

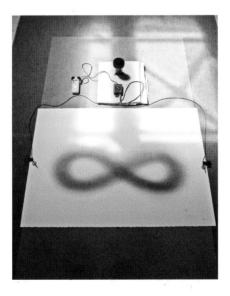

Clockwise from top: *Drawing project plan document, draft 2; pencil tip self-sharpened after nine hours of drawing; tenth hour of Thirty-Four Hours of Infinity beneath the studio skylight.*

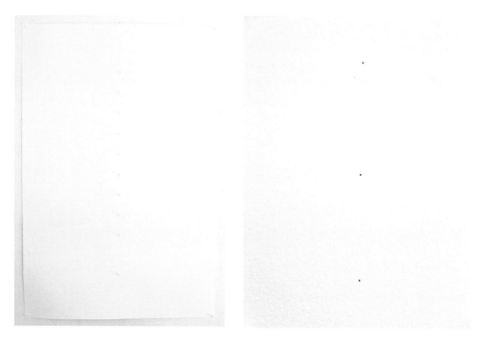

Clockwise from top: Vertical stack of ten pins in the center of Apeiron (alpha); *detail of* Apeiron (alpha) *after removal of pins; fishing line and pins aligned to create the nine holes of the single-point perspective grid on* Apeiron (omega).

studio wall, intending for them to act as sonic sentinels, listening to the rest of the drawings as they were made, absorbing the process as it unfolded. As I continued to make drawings, I began thinking about what else these blank sheets of paper could or should represent. My ongoing research provided an answer.

Turning to Pre-Socratic philosophy for inspiration, I found a good match in Athenian philosopher Anaximander's theory that the universe was created out of a formless, boundless, chaotic space that he named *to apeiron*. I had already decided that these blank drawings would be the only paper in the show that included pin holes—I wanted the actual drawings to appear like floating artifacts, but these blank pages would be ruptured with holes.

The notion of rupturing infinite chaos was intriguing; it felt like the drawings themselves were ruptures in time. Adding more holes to the two blank pages would be a way of signifying the drawings as ruptures as well as imposing order onto chaos, much like ancient Greek creation myths. This led me to incorporate

numerical symbology from the ancient poet Hesiod's conception of the size of the universe. Hesiod claimed that this distance could be measured by "a bronze anvil [forged by Hephaistos] dropped from the highest reaches [that] would descend nine days and then land on the earth on the tenth day after it was left to fall."[1] This was also the same distance from the earth to the bottom of Tartaros, the Greek underworld; hence, the universe was a symmetrical size, with the earth at its center. This notion of "9+1" was a numeric symbol used often in ancient Greek literature and Anaximander's own cosmogony, with the number nine symbolizing great distance or time, and the addition of the tenth unit as an intensifier.[2] I proceeded to puncture the larger blank sheet, *Apeiron (alpha)* (**plate 2**), making ten holes in a vertical line in the center of the paper, with twice the space between the final two holes as there was between the preceding nine holes, referencing the fall of the bronze anvil. I reconfigured the holes for *Apeiron (omega)* (**plate 17**), the final drawing in the show, into an X-shape similar to a connect-the-dots version of a one-point perspective drawing. This left the tenth hole missing, which I intend to be created symbolically by the viewer upon leaving the exhibition.

These absurd, contradictory rules that I created and followed in the generation of these drawings also informed the production of the other two projects in this body of work. These rules and their seemingly obsessive nature help reinforce my belief that no matter how clearly humanity believes it understands the Infinite, we are unable to fully grasp it due to our finite essence—and any attempt to do so results in the acceptance of a beautiful absurdity as one of the rules governing the makeup of the universe.

[1] Hahn, Robert, *Anaximander and the Architects*, SUNY Press, 2001, p. 173.

[2] Ibid, pp. 173–186.

From top: An OCD-afflicted artist's nightmare: the charcoal pencil breaks midway through hour 33 of the 34-hour lemniscate; portrait of the broken pencil; videotaping a one-hour circle.

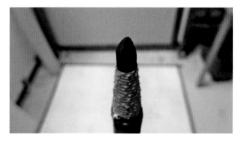

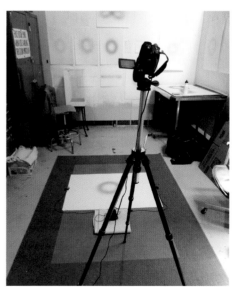

THE PLATES
SET: ONE HUNDRED HOURS OF INFINITY

SUBSET 1: PRELUDE
THE FOUR SHENS

Plate 1. *Prelude. Ten Hours of Infinity: The Four Shens (1, 2, 3, and 4 hours)* • 30" x 30"

19

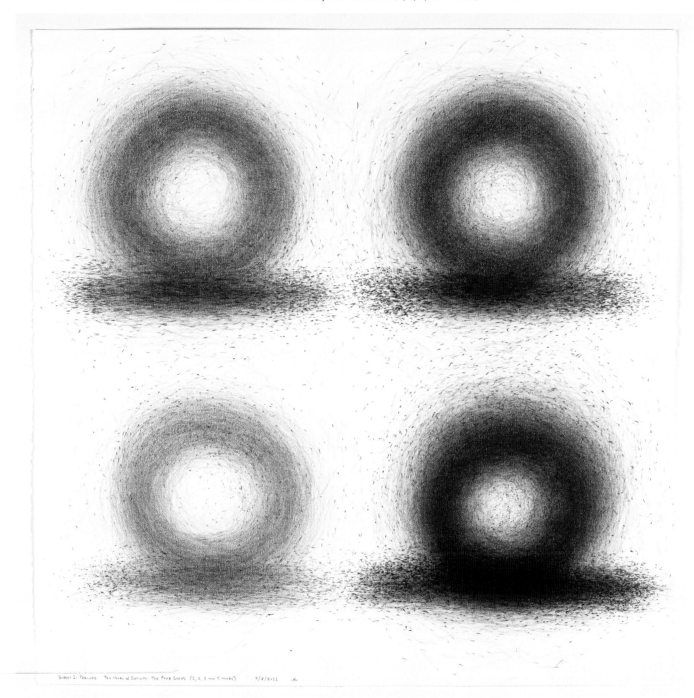

SUBSET 2: THE SEQUENCE
APEIRON (alpha), LEMNISCATES & CIRCLES

Plate 2. *Sequence. Zero Hours of Infinity: Apeiron (alpha)* • 30″ x 44″

21

Plate 3. *Sequence. One Hour of Infinity: Lemniscate* • 44" x 30"

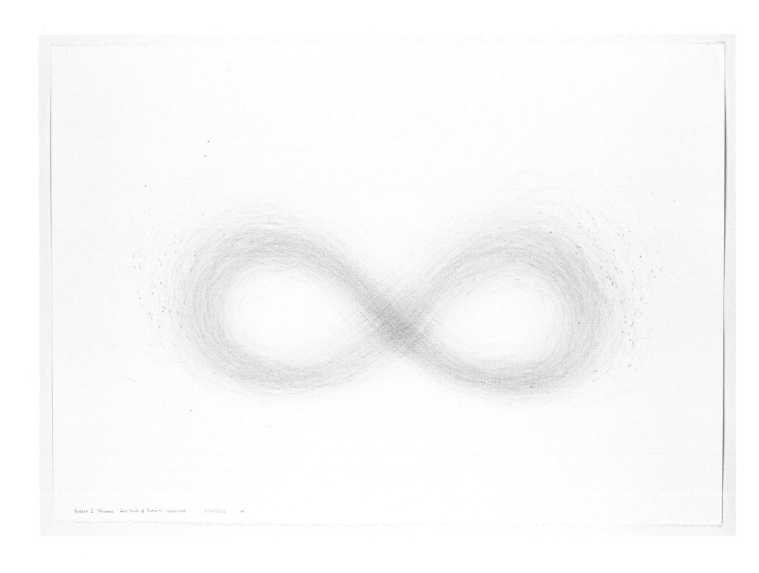

Plate 4. *Sequence. One Hour of Infinity: Circle* • 30″ x 44″

23

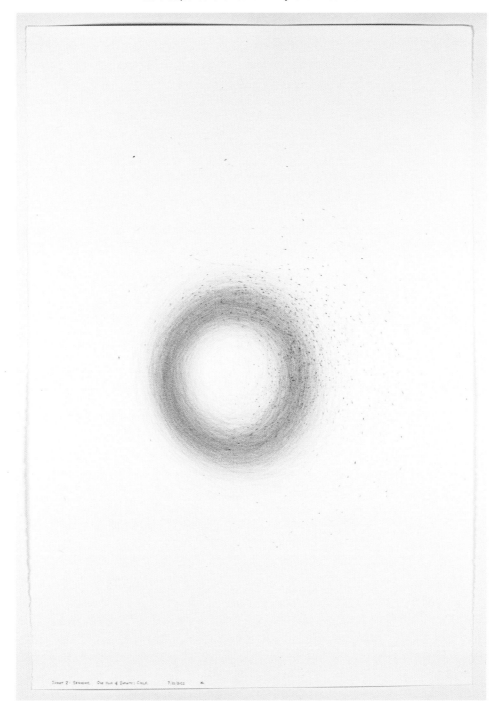

Plate 5. *Sequence. Two Hours of Infinity: Lemniscate* • 44" x 30"

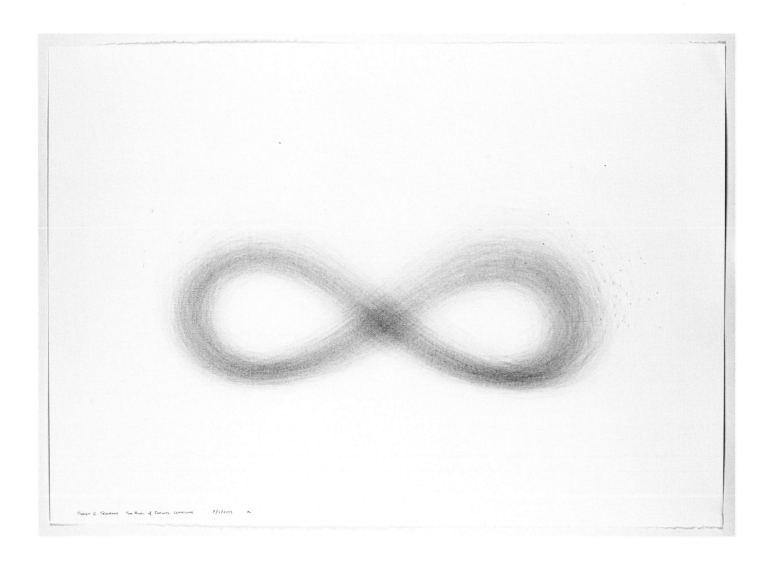

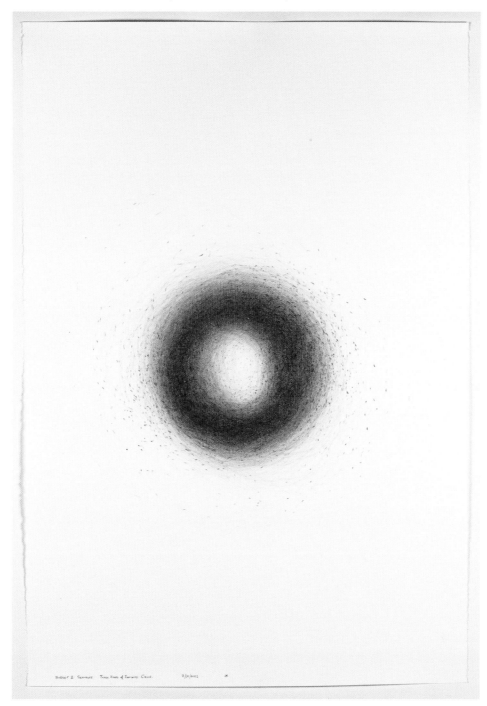

Plate 6. *Sequence. Three Hours of Infinity: Circle* • 30" x 44"

25

Plate 7. Sequence. *Five Hours of Infinity: Lemniscate* • 44″ x 30″

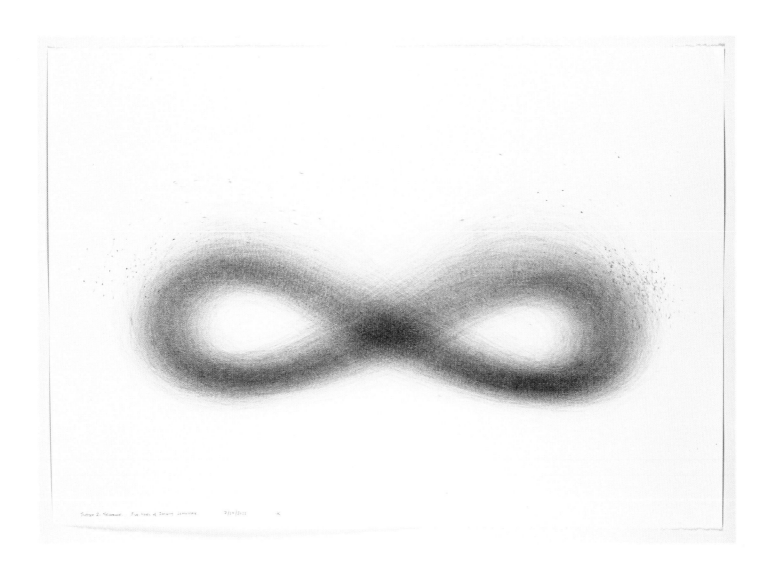

Plate 8. *Sequence: Eight Hours of Infinity: Circle* • 30" x 44"

27

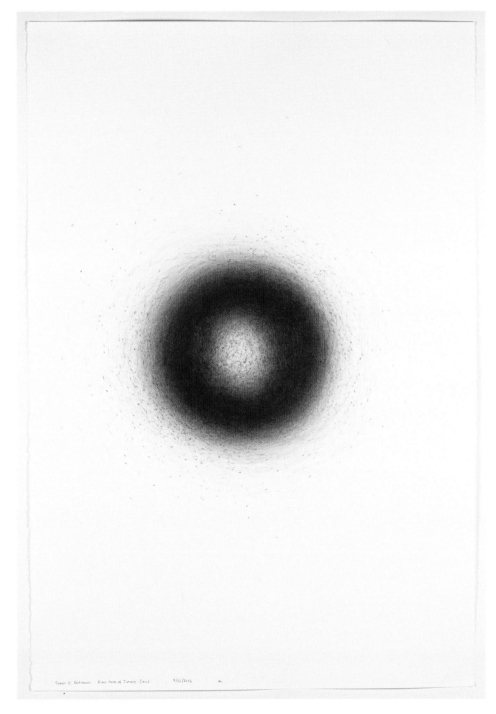

28

Plate 9. *Sequence. Thirteen Hours of Infinity: Lemniscate* • 44" x 30"

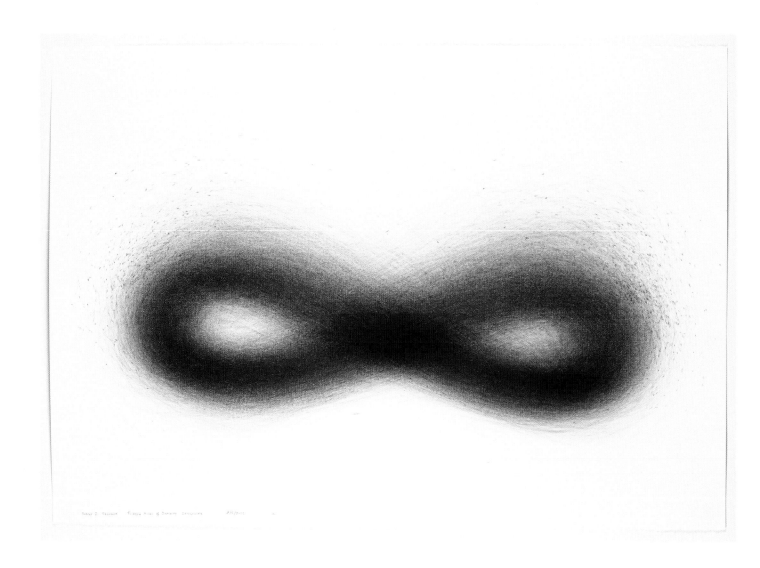

Plate 10. *Sequence. Twenty-One Hours of Infinity: Circle* • 30" x 44"

29

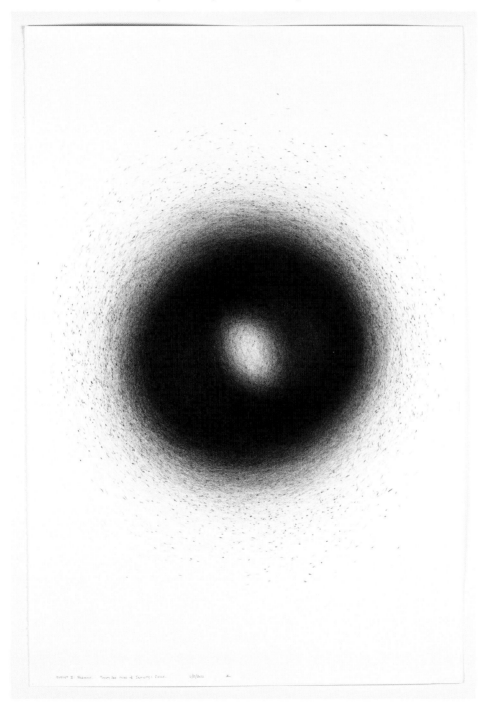

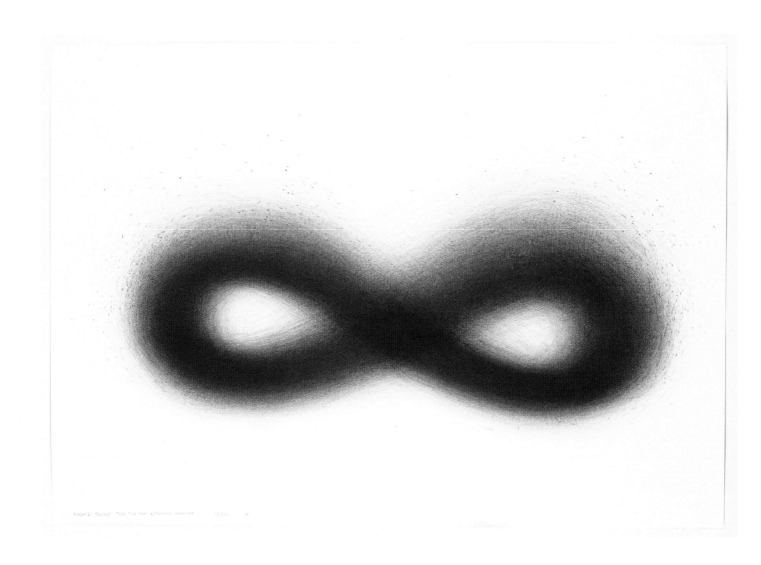

Plate 11. *Sequence. Thirty Four Hours of Infinity: Lemniscate* • 44" x 30"

SUBSET 3: CODA
CIRCLES, A LEMNISCATE & APEIRON (omega)

Plate 12. *Coda. Fifty Minutes of Infinity: Circle* • 22″ x 30″

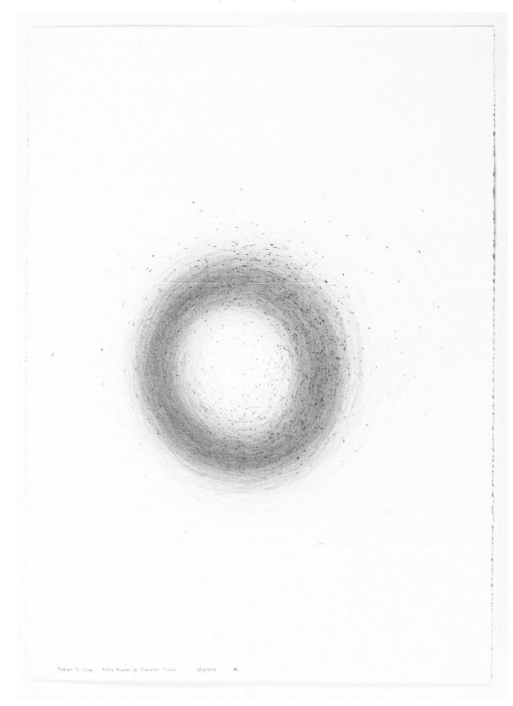

Plate 13. *Coda. Thirty Minutes of Infinity: Circle* • 22" x 30"

33

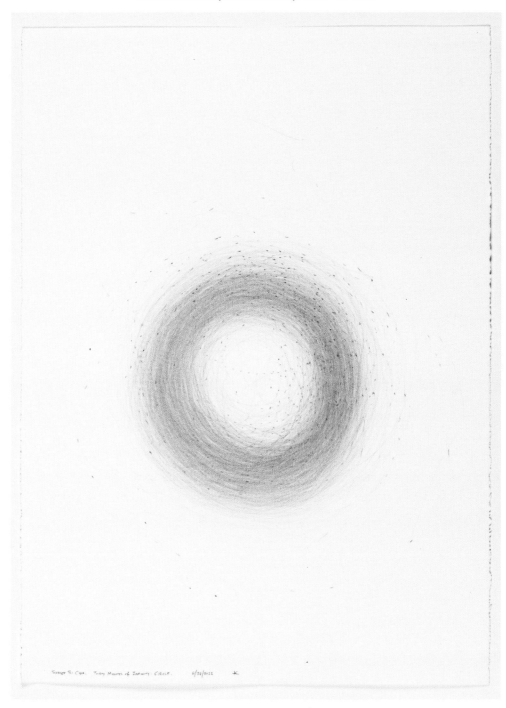

Plate 14. *Coda. Twenty Minutes of Infinity: Circle* • 22″ x 30″

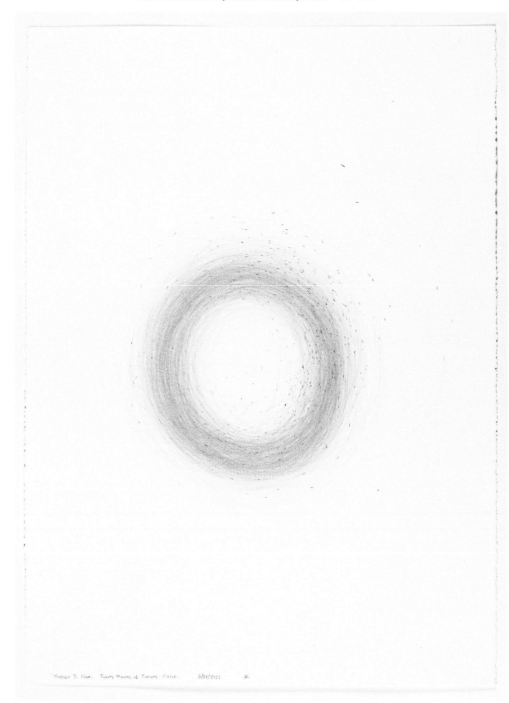

Plate 15. *Coda. Ten Minutes of Infinity: Circle* • 22″ x 30″

35

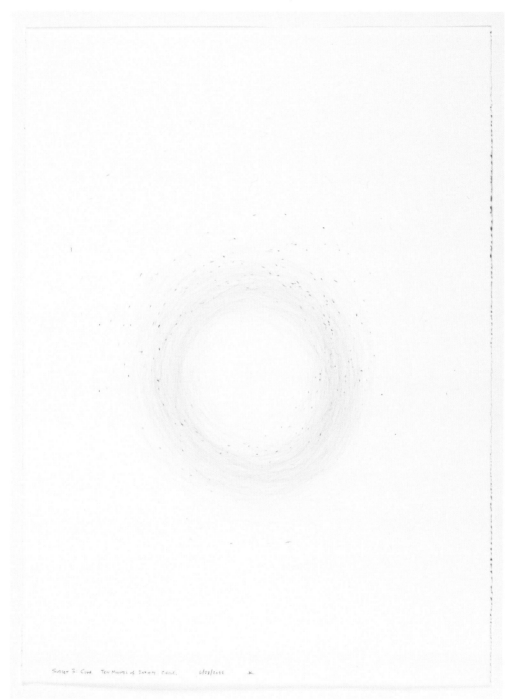

Plate 16. *Coda. Ten Minutes of Infinity: Lemniscate* • 30″ x 22″

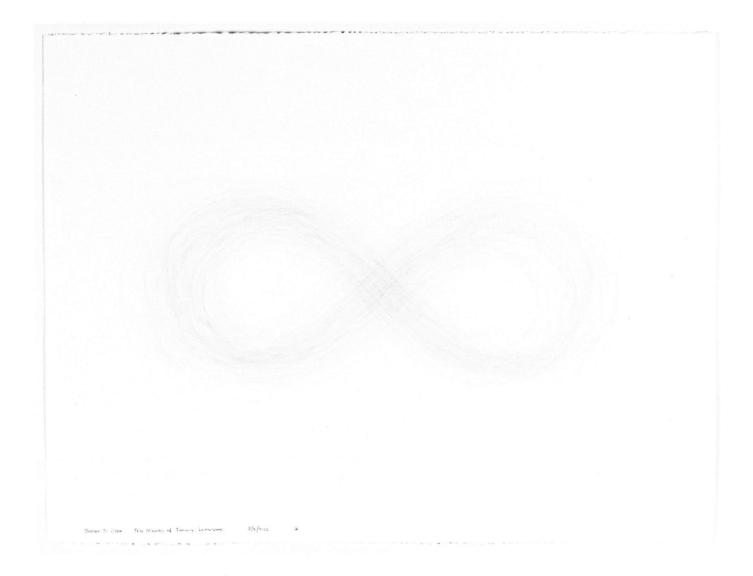

Plate 17. *Coda. Zero Minutes of Infinity: Apeiron (omega)* • 30″ x 22″

SOUND & VIDEO INSTALLATION:
ONE HOUR OF INFINITY

Accompanying the drawings in *One Hundred Hours of Infinity* is a sound and video installation piece, *One Hour of Infinity*. While making this body of work during the summer of 2011, I videotaped myself drawing the one-hour lemniscate (**plate 3**) from start to finish in a single take, using only the natural light from my studio's skylight.

The single shot of the video is close-cropped on the paper, which rests on the floor. At the beginning, my charcoal pencil dangles above the paper while attached to fishing line, then begins drawing. Over the course of the hour the drawing slowly builds up. I began the drawing in the morning at about 6:30 am, and because of the ongoing sunrise the quality of light slowly and subtly changes as the video progresses. Mistakes are not edited out: the pencil skips across the paper or out of frame, the auto-focus on the video camera loses focus on the paper while following the pencil; the drawing in the video is presented upside-down when compared to the actual, authentic drawing hanging in the show due to the positioning of the camera.

Sonically, the piece works as a bridge between the acoustic properties of the gallery space where the exhibition takes place and the space of my studio where the recording was made. The two-channel soundtrack—a mix between two recordings, one of contact microphones placed directly on either end of the paper, the other from a stereo microphone capturing the sound of the drawing activity as well as the room's ambient sound—is played back on speakers placed on the floor at either side of the gallery space containing the video. When the viewer/listener sits directly in the video's optimal viewing position, the sound of the pencil moving back and forth is heard passing directly through the listener, bouncing between the walls: a physical interaction between audience and sonic object, a wave of time not dissimilar to a pendulum's swing.

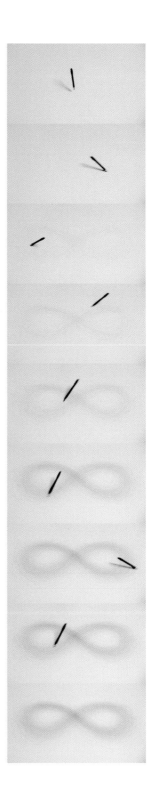

TWELVE HOURS OF INFINITY: AMDUAT

∞ – 12

ABOUT *TWELVE HOURS OF INFINITY: AMDUAT*

In this second variation on the theme of the imperfect Infinite, I turned to ancient Egypt for inspiration. As one of humanity's oldest civilizations, the culture of ancient Egypt has been an inspiration to me for as long as I can remember. Finding points of contact with ancient civilizations has been one of the goals of this project, and upon being presented with the opportunity to exhibit a series of drawings in the Kelsey Museum of Archaeology, I was keen to use these images to make a more overt connection to the collections held there.

One of the ancient texts of the Egyptian afterlife is called the *Amduat*. It traces the journey of the sun during the twelve hours of night before it is reborn every morning at sunrise. This book relates to the idea of an imperfect infinity, as the Egyptians believed the sun was eternal, reborn every day for eternity rather than a finite star destined to extinguish itself.

The *Amduat*'s own subject matter provided me with a given duration of hours around which to construct a short series of drawings. Since the text dealt with the nighttime life of the sun god, I decided to create these drawings in near darkness, as opposed to the sunlight-soaked drawings of the *One Hundred Hours* project. *Twelve Hours of Infinity* contains drawings of four hieroglyphs related to Infinity, the measurement of time and the birth/death cycle of the sun. I divided the drawings into two subsets entitled *Red Land* and *Black Land*—the names the ancient Egyptians gave to the western desert and the fertile Nile river valley respectively. Using this metaphor was a way for me to introduce color into the drawings as well as to make a reference to ancient Egyptian papyri that used red ink for text that is "charged" in some way—such as the names of deities—and black ink for the rest of the text.

Red Land hieroglyphs

> **Re (plate 18)**. The hieroglyph for the sun god was an obvious choice and begins the series with a single hour.

> **Renpet (plate 19)**. As the sign for "year," this two-hour drawing imposes upon the drawings a paradoxical context of time measuring time: I drew a year for two hours; how is that even possible?

> **Akhet (plate 20)**. The sun disc looming above the horizon, caught in its state of rebirth, a three-hour drawing.

Black Land hieroglyphs

> **Shen rings (plates 21–23)** once again appear, as they did in the *Prelude* in *One Hundred Hours of Infinity*. Using the same technique, but giving each shen its own page this time, I created drawings that were one, two, and three hours in duration.

DRAWING SCHEMATIC,
KELSEY MUSEUM NEWBERRY GROUND FLOOR CORRIDOR:
TWELVE HOURS OF INFINITY (AMDUAT)

SUBSET 1: Re (N5), Renpet, Akhet

| 1 hour | 2 hours | 3 hours |

SUBSET 2: Three Shens

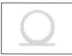

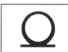

| 1 hour | 2 hours | 3 hours |

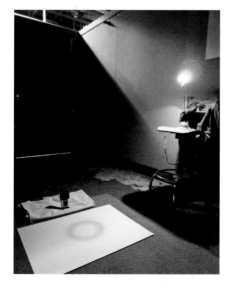

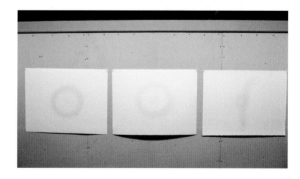

Clockwise from top: Amduat drawing project planning document, draft 3; initial test drawings with red graphite; drawing the three-hour Shen in near darkness.

THE PLATES
SET: TWELVE HOURS OF INFINITY—AMDUAT

SUBSET 1: RED LAND
RE, RENPET & AKHET

Plate 18. *One Hour of Infinity: Re* • 30" x 22"

43

Subset 1 One Hour of Infinity : RE ·K 9/19/2011

Plate 19. *Two Hours of Infinity: Renpet* • 30" x 22"

Subset 1 Two Hours of Infinity Renpet JK 7/28/2011

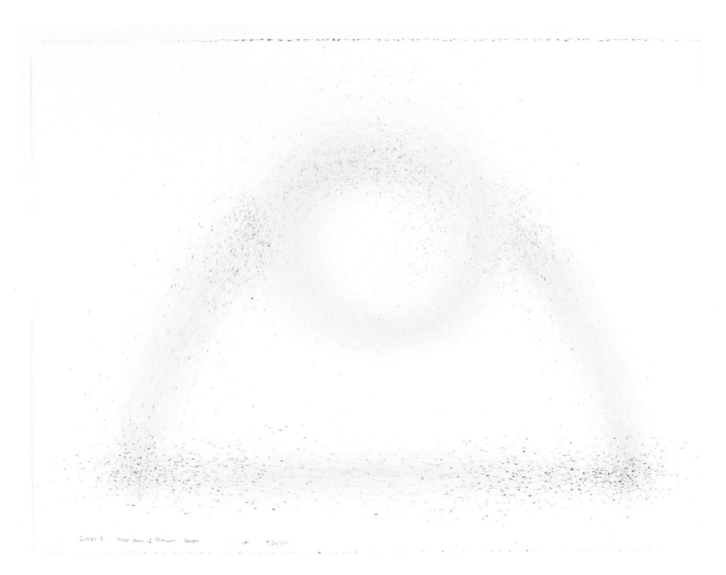

Plate 20. *Three Hours of Infinity: Akhet* • 30" x 22"

45

SUBSET 2: BLACK LAND
THREE SHENS

Plate 21. *One Hour of Infinity: Shen* • 30" x 22"

47

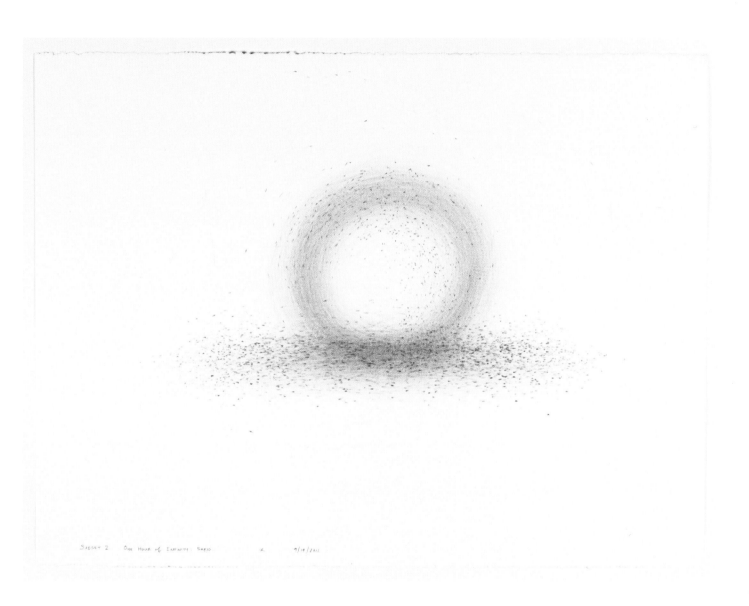

Plate 22. *Two Hours of Infinity: Shen* • 30″ x 22″

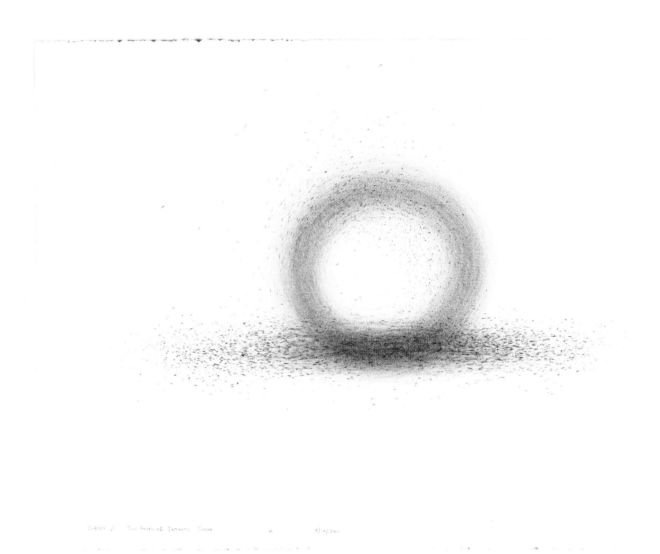

Plate 23. *Three Hours of Infinity: Shen* • 30″ x 22″

49

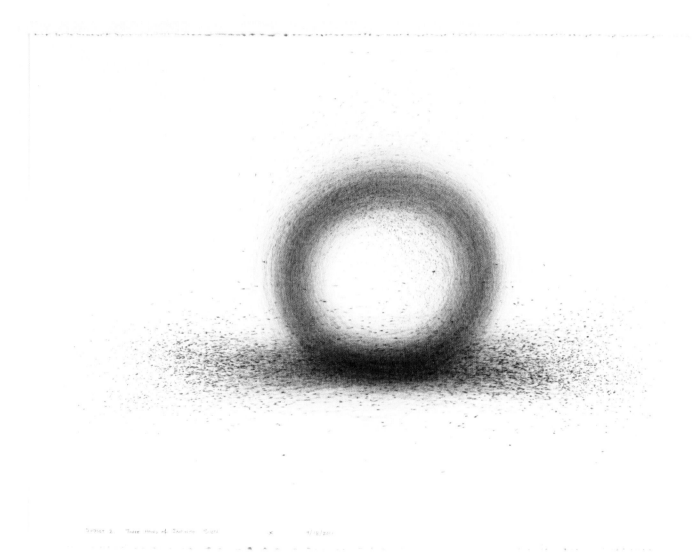

AN HOUR OF INFINITY

 $\infty - 1$

ABOUT *AN HOUR OF INFINITY*

The third component of the *Hours of Infinity* project is a site-specific performance designed for the Kelsey Museum of Archaeology on the campus of the University of Michigan. The piece synthesizes many of the ideas I have been working with for the past several years, including the fishing line drawing process of *One Hundred Hours of Infinity*, the composition of graphic notation for live performance, attentive listening to nonmusical sound, and my theories regarding the collision of contemporary sonic events and historical museum objects resulting in the creation of so-called active sounds of history (see definition, page 8).

Since much of my work—and this project in particular—is attentive to long segments of time, it felt particularly appropriate to present the performance component of this project in a museum dedicated to the display of ancient objects, particularly collections from two of the cultures whose philosophies directly influenced my thinking while creating this body of work.

The performance consists of three components:

- **Eight drawing performers**, drawing circles and lemniscates for the duration of the hour using the same fishing line and charcoal method I used in creating the rest of the work, spread across both floors of the museum's permanent collection galleries.

- **Two surround sound installations** using sounds recorded in the museum as source material for looping compositions that gradually change over the course of the hour.

- **Two musicians** performing site-specific, hour-long scores: one uses reproduced paintings from a mysterious room in the ancient city of Pompeii as its source material; the other uses the inscriptions of gibberish text on an ancient Babylonian incantation bowl.

These components combine to create a subtle yet complex sonic environment deeply connected to the acoustics and collections of the museum itself, injecting a layer of low-volume sound that encourages the audience to listen closely enough that the sounds of the museum itself become amplified within the attention of the listeners. With the performers spread throughout the galleries, their gaze directed downward, they become temporary living objects in the museum's collection. The audience is encouraged to wander as they normally would throughout the museum, creating their own personal mix of the generated sounds.

Much like the typical experience of visiting a museum, this hyperreal, performative segment of time sets out to lead the audience along certain paths, yet due to the audience's group dynamics a linear experience is an unreal expectation—much as didactic museum exhibitions themselves can only suggest a pathway for independently minded visitors.

By providing a series of fixed sonic points in time, this performance challenges the audience to analyze their own behavior in a museum, as well as their own relationship to time itself.

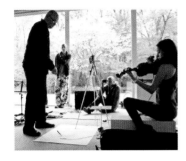

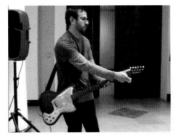

Above, top to bottom: *Performing live drawing with Collin McRae on violin at Glazenhuis, Amsterdam (still from video shot by Theresa Sauer);*
James Warchol playing guitar at the University of Michigan Museum of Art during a performance of Kannenberg's site-specific video score Collections: UMMA *(still from video shot by Reed Esslinger).*

Right, top to bottom:
Map 1 *– Kelsey Museum Ground Floor performance mockup;*
Map 2 *– Kelsey Museum Second Floor performance mockup.*

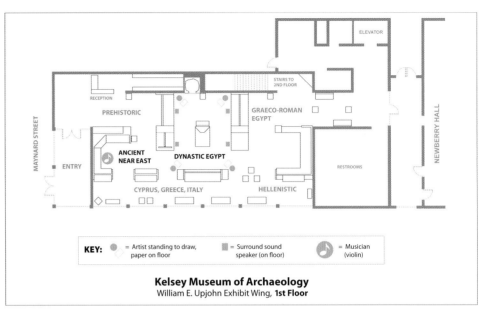

KEY: = Artist standing to draw, paper on floor ▪ = Surround sound speaker (on floor) ♪ = Musician (violin)

Kelsey Museum of Archaeology
William E. Upjohn Exhibit Wing, **1st Floor**

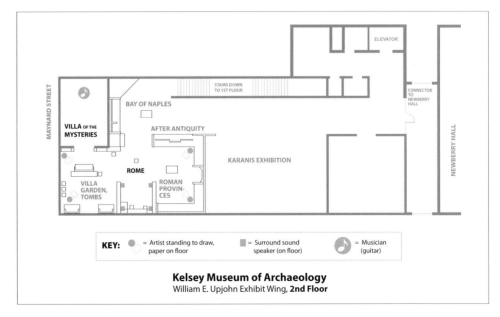

KEY: = Artist standing to draw, paper on floor ▪ = Surround sound speaker (on floor) ♪ = Musician (guitar)

Kelsey Museum of Archaeology
William E. Upjohn Exhibit Wing, **2nd Floor**

Are the audience members able to stay quiet for the entire hour? Do they choose one portion of the performance to focus on, or do they try to take it all in at once? Do they return to sonic objects they particularly like? Do they decide to rush through quickly and leave after five minutes? My interest in mounting this piece has been as much about the audience reaction to the three components of the piece as it has been about the actual content of the piece itself.

Live Drawing Performers

Two sets of four performers, one set on each floor of the museum, replicate the fishing line drawing technique I developed for *One Hundred Hours of Infinity*. In the Dynastic Egypt gallery on the ground floor of the museum, the four artists, positioned around the coffin of Djehutymose, attempt to each draw their own circle. The circular aspects of ancient Egyptian notions of time and resurrection are here echoed by the drawings, as well as the performers' somewhat circular placement around the corners of the room (see **Map 1**).

On the second floor, four more artists attempt to draw lemniscates while spread throughout the Ancient Roman galleries. Their placement throughout the galleries approximates the shape of a lemniscate (see **Map 2**). With the drawings placed on the floor rather than on a wall, the sounds of the drawing process become as important as the process's visual output. My first experience performing this drawing process in front of an audience involved amplifying and electronically manipulating the sound of the drawing. For *An Hour of Infinity* I have decided to keep the drawing sounds pure and unaltered, allowing the audience and the performers to perceive a more direct (some might say *more authentic*) correlation between the sounds and the objects generating them.

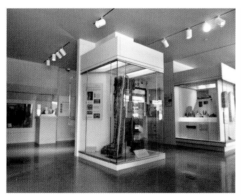 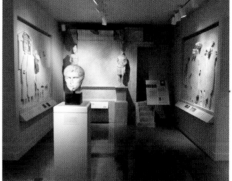

Left to right: *Dynastic Egypt gallery, site of live circle drawings and footsteps surround sound installation; Temple Gentis Flaviae reconstruction, site of museum archives surround sound installation.*

Surround Sound Installations

Two four-channel surround sound pieces accompany the drawing performers on both floors. In the Dynastic Egypt gallery, a surround recording of my own footsteps walking in a circle on the creaky wooden floor of the main hallway of Newberry Hall (the original site of the Kelsey Museum) is played in a loop, gradually shifting out of phase with itself over the course of the hour to produce a sound not unlike the swishing of the charcoal pencils on the paper as generated by the drawing performers. Here the sound of the Kelsey itself comes to the fore with a sound sample that evokes a sensation of ghosts, a haunting sonic object that references life after death, a sonic object on display in a gallery filled with funerary objects from ancient Egypt that were meant to serve their owners in the afterlife.

Simultaneously, upstairs in the Ancient Roman galleries a second surround sound piece uses the same gradual phase-shift structure with another sound recorded in the Kelsey as its source material: a recording of myself opening and closing drawers in the museum's off-limits basement archives. This sound is presented in front of the Kelsey's reconstruction of the Temple Gentis Flaviae, wherein ancient priests would have held a similar archive of sacred objects off-limits to the general public, only to be viewed by those with sufficient economic or political power.

Giving voice to the Kelsey's out-of-view collections within this space questions the power dynamics of museums as a whole, examining the history of the public's real access to museum materials. Within the academic discipline of Museum Studies there has long been a debate about whether museums should be modeled after temples (like the Gentis Flaviae) or forums (which would allow for a more democratic method of distributing knowledge and selecting the materials best suited to the museum audience's needs). This sound piece attempts to metaphorically bring the forum into the temple, setting up a feedback loop between two possible museum identities.

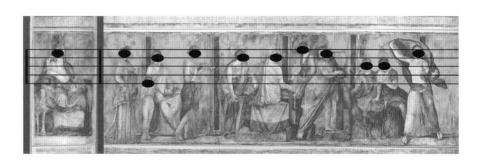

Spread: Barosso Room paintings with musical notation mapping for site-specific score.

Site-Specific Musical Scores

Two objects in the Kelsey's collection serve as the source material for the musical scores performed during *An Hour of Infinity*. One object is converted into a score of traditional musical notation, while the other acts as an ancient graphic score—free of traditional musical notes yet evocative of sound in a visual form.

On the ground floor adjacent to the Dynastic Egypt gallery, a painted clay Parthian Period (248 BCE–226 CE) incantation bowl excavated at the Mesopotamian city of Seleucia (in modern-day Iraq) serves as a graphic score for violinist Collin McRae (see photo, page 56). An object meant to accompany an ancient ritual, the text inscribed on it is actually gibberish—a nonexistent tongue meant to be readable by inhabitants of the spirit world. As an artist and musician, McRae investigates written forms of language and the transformations of meaning across the translation of words from one language to another, making this bowl the perfect source for her to interpret as a musical score for an improvised performance.

Upstairs in the Roman galleries, the Room of the Mysteries (also known as the Barosso Room) contains a series of watercolor paintings commissioned by Francis Kelsey, founder of the Kelsey Museum collections, that were created by Italian artist Maria Barosso in the late 1920s. The paintings are scale reproductions of the frescoes from one room in the Villa of the Mysteries at Pompeii. A somewhat circular suite of images, the paintings cover all four walls of the room and move in clockwise sequence from one side of the room's entrance to the other. However, what the figures in the paintings are meant to represent is still uncertain to archaeologists and art historians. It is these figures that served as the basis for the musical notation I generated, overlaying a musical staff onto the paintings in sequence and plotting a note where each figure's eyes and ears intersect the staff (see below). Two rests in the notation serve as placeholders for the figures on the damaged panel whose heads no longer exist, creating a gap in the performance of the note sequence. This series of notes and rests are played by guitarist James Warchol, who plays the note sequence repeatedly over the course of the hour but is encouraged to improvise within the repetition, eventually returning to a straight performance of the original sequence of notes at the end of the hour. A circular pattern with infinite possible permutations, this score and performance work together to embody the notion of beautiful imperfection within the human experience of the Infinite that my entire project seeks to explore.

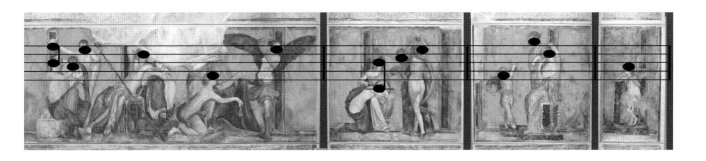

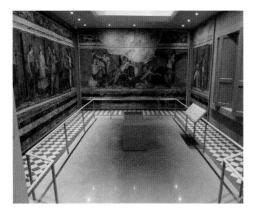
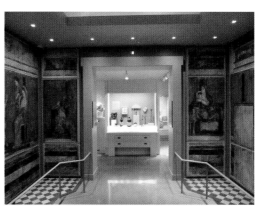

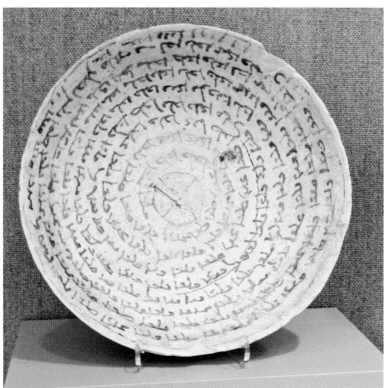

Top to bottom: *Two views of the paintings in the Kelsey Museum Barosso Room; Parthian Period Iraqi incantation bowl with gibberish inscription, Kelsey Museum.*

ACTUS ET POTENTIA

The snapshots on these two pages contain early experiments with alternative forms of drawing. These explorations directly preceded the works in *Hours of Infinity*.

Clockwise from left: *Standing on paper with wet boots, rotating in a circle for ten minutes; Sound mapping (left hand, left ear); Pressure diptych, graphite powder.*

Above: *Trying to draw a square for thirty minutes with a piece of charcoal attached to fishing line.* **Left, top to bottom:** *Trying to draw a straight line for ten minutes with a piece of charcoal attached to fishing line; detail; extreme detail of paper's edge.*

BIOGRAPHY: JOHN KANNENBERG

photograph by Reem Gibriel

John Kannenberg creates quietly reflective work in image and sound that blurs the boundaries between intention and accident. Using techniques derived from free improvisation, musical composition, rules-based process drawing, and digital/analog minimalism in their construction, his works deal with a wide variety of themes, including the human experience of time, the psychology of collection, the sonics of space and place, and the processes of both making and observing art.

John's work has been presented extensively worldwide, including appearances at the 2011 Notations.NL festival in Amsterdam, the 2010 100 LIVE festival in Cairo, the 2009 Switch ON Festival in Kuala Lumpur, the 2008 Sonic Fragments Festival at Princeton, the 2007 Laptopia Festival in Tel Aviv, the 2006 Soundwalk festival in Long Beach, and the 2005 John Cage Musicircus at the Museum of Contemporary Art Chicago. His hour-long suite of composed field recordings *A Sound Map of the Egyptian Museum, Cairo* was recently presented as an installation at the 2011 International Conference on Acoustic Ecology in Corfu, Greece.

As a composer, John's graphic notation work has been published in Theresa Sauer's comprehensive survey of post-Cageian graphic scores *Notations 21* and performed by Manchester, UK's Chiasmus Ensemble, while his site-specific video score *Collections: UMMA* has been performed at the University of Michigan Museum of Art. Recordings of his sound works have been released by a variety of international record labels and websites, including Entr'acte, 3LEAVES, Crouton, Disquiet, Grain of Sound, Furthernoise, Flaming Pines, and Why Not LTD. John was also a contributor to and occasional guest host of Philip von Zweck's *Something Else* program of experimental music and radio art on WLUW 88.7FM in Chicago from 2000 to 2009.

John's work as a curator has included exhibitions of contemporary artworks for radio, online, and physical venues including the Biennale of Electronic Arts in Perth, London's ResonanceFM art radio station, and the Jean Paul Slusser Gallery at the University of Michigan. He has also recently curated a display of ancient Egyptian soundmaking objects for the Kelsey Museum of Archaeology and lectured on the sonic experience of museums with Dr. T. G. Wilfong during the 2011–2012 University of Michigan Museum Studies *Cross Currents* series.

Since April 2002, John has served as the creator, designer, and curator of Stasisfield.com, an experimental record label and interdisciplinary digital art space, presenting works by a diverse collection of artists from around the globe. More information can be found online at **johnkannenberg.com**.

BIOGRAPHY: MARC WEIDENBAUM

photograph by Marc Weidenbaum

Marc Weidenbaum founded the website **Disquiet.com** in 1996. It focuses on the intersection of sound, art, and technology. He has written for *Nature*, the website of *The Atlantic*, NewMusicBox.org, *Down Beat*, and numerous other publications.

He has commissioned and curated sound/music projects that have featured original works by Kate Carr, Marcus Fischer, John Kannenberg, Tom Moody, Steve Roden, Scanner, Roddy Shrock, Robert Thomas, Pedro Tudela, and Stephen Vitiello, among many others. He moderates the Disquiet Junto group at Soundcloud.com; there dozens of musicians respond to weekly Oulipo-style restrictive compositional projects.

Books containing comics he edited include Jessica Abel's *Soundtrack*, Justin Green's *Musical Legends*, and Adrian Tomine's *Scrapbook*. He was editor-in-chief of the American edition of Japan's largest manga magazine, *Shonen Jump*. He has occupied senior managerial roles at print publications and web firms, and in brand strategy.

He lives in San Francisco in a neighborhood whose soundmarks include Tuesday noon civic alarms as well as persistent seasonal fog horns from the nearby bay. He also resides at **twitter.com/disquiet**.

BIOGRAPHY: T. G. WILFONG

Terry G. Wilfong is Associate Professor of Egyptology in the Department of Near Eastern Studies and Associate Curator for Graeco-Roman Egypt in the Kelsey Museum at the University of Michigan. He received his Ph.D. in Egyptology from the University of Chicago, where he curated his first exhibition at the Oriental Institute Museum.

Since coming to the University of Michigan in 1994, he has curated numerous exhibitions on a variety of topics at the Kelsey Museum, most notably "Women and Gender in Ancient Egypt," "Music in Roman Egypt," "Archaeologies of Childhood," and the current "Karanis Revealed," in addition to curation of the Kelsey Museum's permanent installation on Graeco-Roman Egypt.

He has published and lectured extensively on a wide variety of topics, including books and articles on gender in the ancient world, Egyptian religion in the later periods, and Coptic texts. His current project is a book tentatively titled *Egyptian Anxieties: Living in an Oracular Age.*

photograph by Sebastián Encina

ACKNOWLEDGMENTS

Many thanks to my MFA Thesis Committee at the University of Michigan School of Art and Design: Andy Kirshner (chair), Larry Cressman, Stephen Rush, and Terry Wilfong. I am also grateful to many other University of Michigan faculty and staff for their advice and assistance over the past three years: James Cogswell, Malcolm Tulip, Doug Hesseltine, Stephanie Rowden, Thylias Moss, Endi Poskovic, John Marshall, Franc Nunoo-Quarcoo, David Chung, Mark Nielsen, Stephen Schudlich, Kath Weider-Roos, Ray Silverman, Brad Taylor, Janet Richards, Stashu Kybartas, Scott Meier, Sebastián Encina, and Laurie Talalay.

Special thanks to my friends and colleagues in the School of Art and Design's 2012 MFA cohort for their incredible camaraderie, collaboration, and support: Lea Bult, Reed Esslinger, Emilia Javanica, Amanda Lilleston, Yuan Ma, Collin McRae, Meghan Reynard, and James Rotz. Many thanks to Ann Bartges for her invaluable assistance in the final stages of preparation for these projects.

Thanks also to the many friends who spent too much time listening to me talk about Infinity, museums, Egyptology, and/or rules in the past two years: Justin Dimmel (the Fifth Beatle of my thesis committee), Glenn Bach, Travis Pinter, Kristopher Hunt, Dan Curley, Reem Gibriel, Susan Stacks (progenitor of the fishing line), Askia Nasir Bilal, Charlie Michaels, Michael Borowski, Sean Darby, Erica Buss, James Cook, Gina Konstantopoulos, Emma Sachs, Kate Larson, Megan Banka, Antje Gamble, Lindsay Stern, Mia Cinelli, Chantal Gibson, Theresa Sauer, Mohammed Abdallah, John Ritterbush, Be Seppy, Matthew Sansom, Anastasia Chrysanthakopoulou, and Lindsay Ambridge.

My infinite (pun intended) gratitude to Philip von Zweck, whose encouragement set me on this path in the first place.

I am grateful to the Kelsey Museum of Archaeology and the University of Michigan School of Art and Design for providing the venues within which to present these projects, and the resources to make them a reality.

Download *Three Hours of Infinity*, a free mp3 album of drawing sounds recorded for this project at **stasisfield.com/infinity**

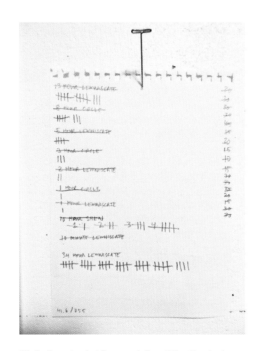

Studio time sheet at the completion of One Hundred
Hours of Infinity.